COLORING IN GRAYSCALE: THE BASICS

COLORS
The existing shading on grayscale pages creates a beautiful, rich color palette when blended with multiple shades of the same color. Using multiple variations of blue, green, yellow, etc. will allow you to create a more lifelike final image.

MATERIALS
Colored pencils, watercolor pencils, blendable markers and crayons all work well for grayscale coloring. Use gel pens, fine tipped markers to enhance detail, and a watercolor brush or sponge for better blending technique.

BLENDING WITH GRAYSCALE
Try coloring over the darker gray areas with your darkest color shades for greater depth and saturation.

HAVE FUN
There is no wrong way to color. Just do what feels right!

CONNECT WITH US
We love seeing all the gorgeous works of art created with our grayscale coloring books. Post photos of your finished pages with your Amazon review, tweet at @HartGrayscale, or share them in the Grayscale Coloring Group on Facebook!

Be the Light

A GRAYSCALE ADULT COLORING BOOK

Let each lighthouse lead the path to vibrant peace.

Lighthouses are renown for being beacons of safety. We hope that each page allows you to find that peaceful place within yourself that is home.

Be the Light is the ideal way to utilize the colors in your imagination to bring these gorgeous scenic buildings to life.

These grayscale images are designed to stimulate your creativity, improve your fine motor skills, and induce a state of calm meditative focus.

Fine tip markers, colored pencils and watercolor mediums are all ideal for bringing these pages to life.

© 2016 Hart Grayscale Coloring

A Division of Hart House Media LLC

Austin, TX

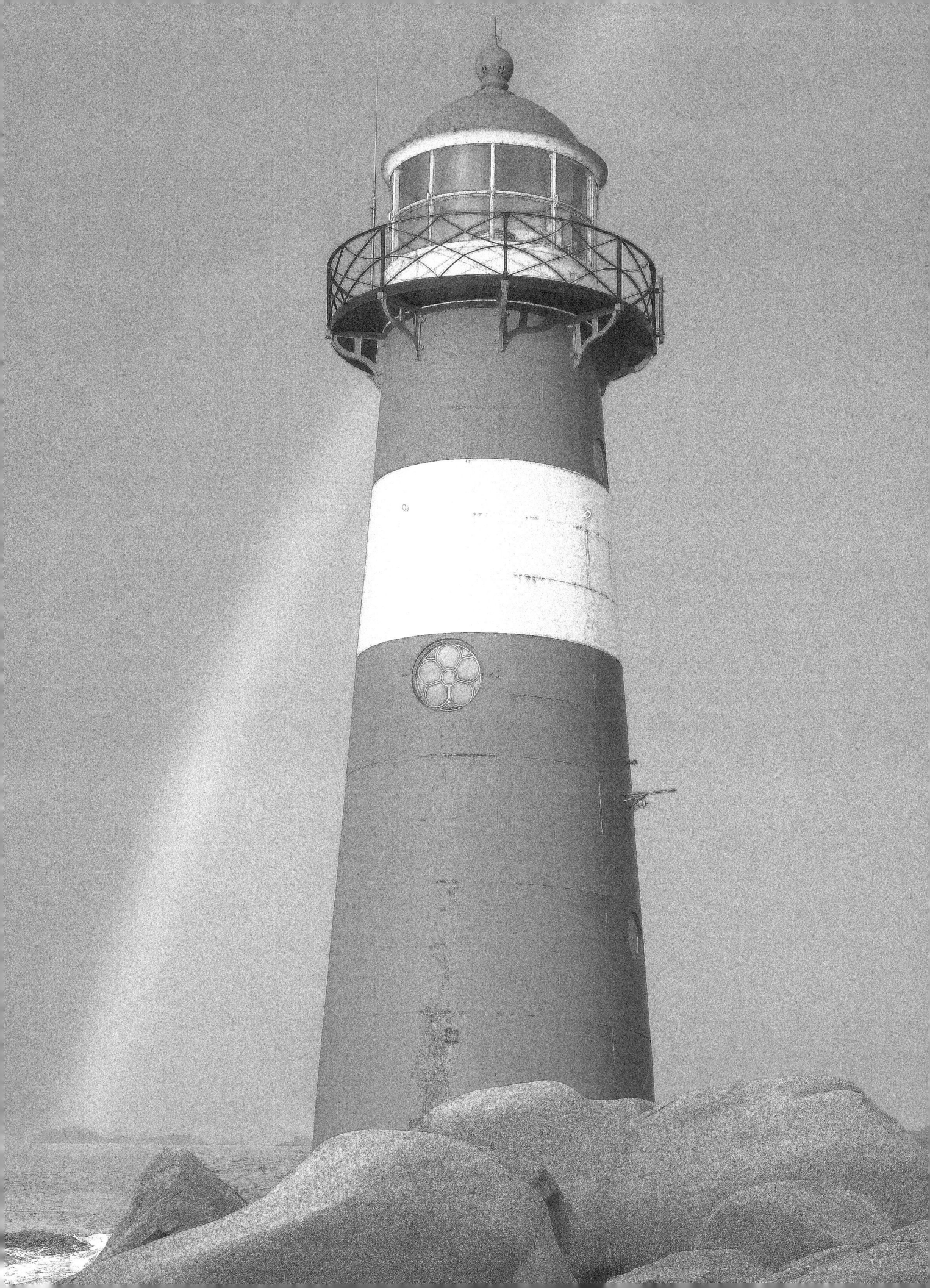

Materials Used:

Colored By:

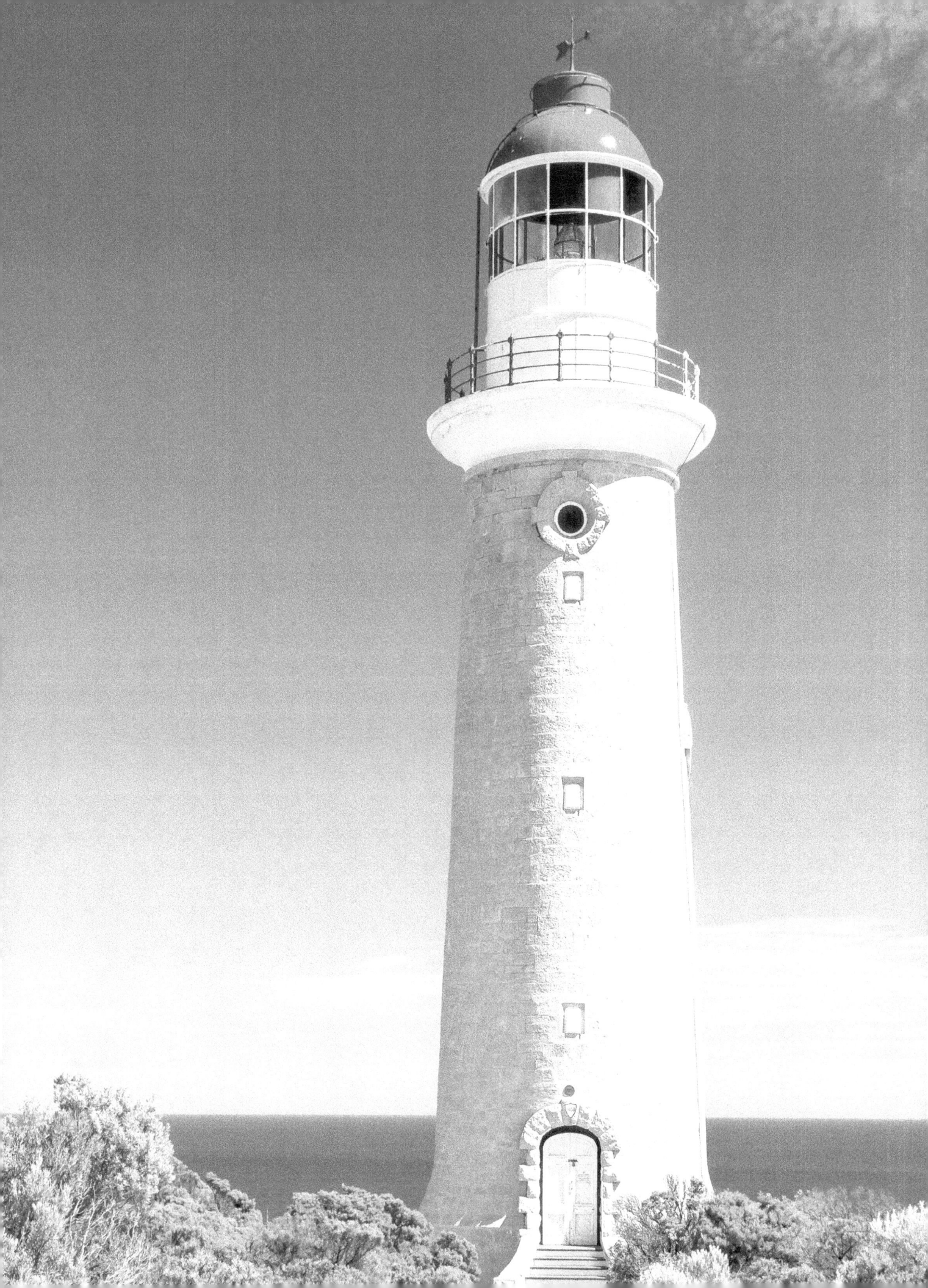

Materials Used:

Colored By:

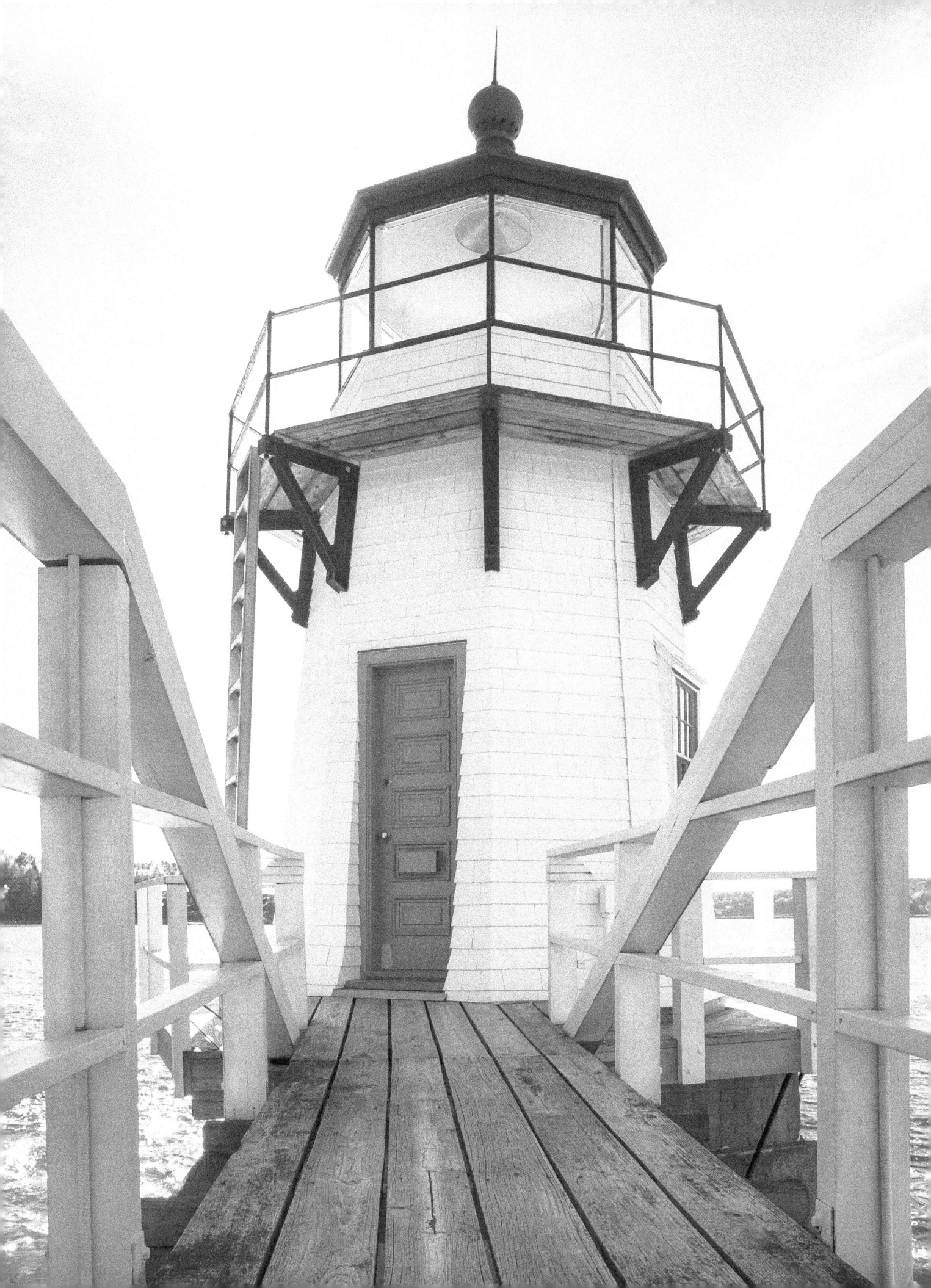

Materials Used:

Colored By:

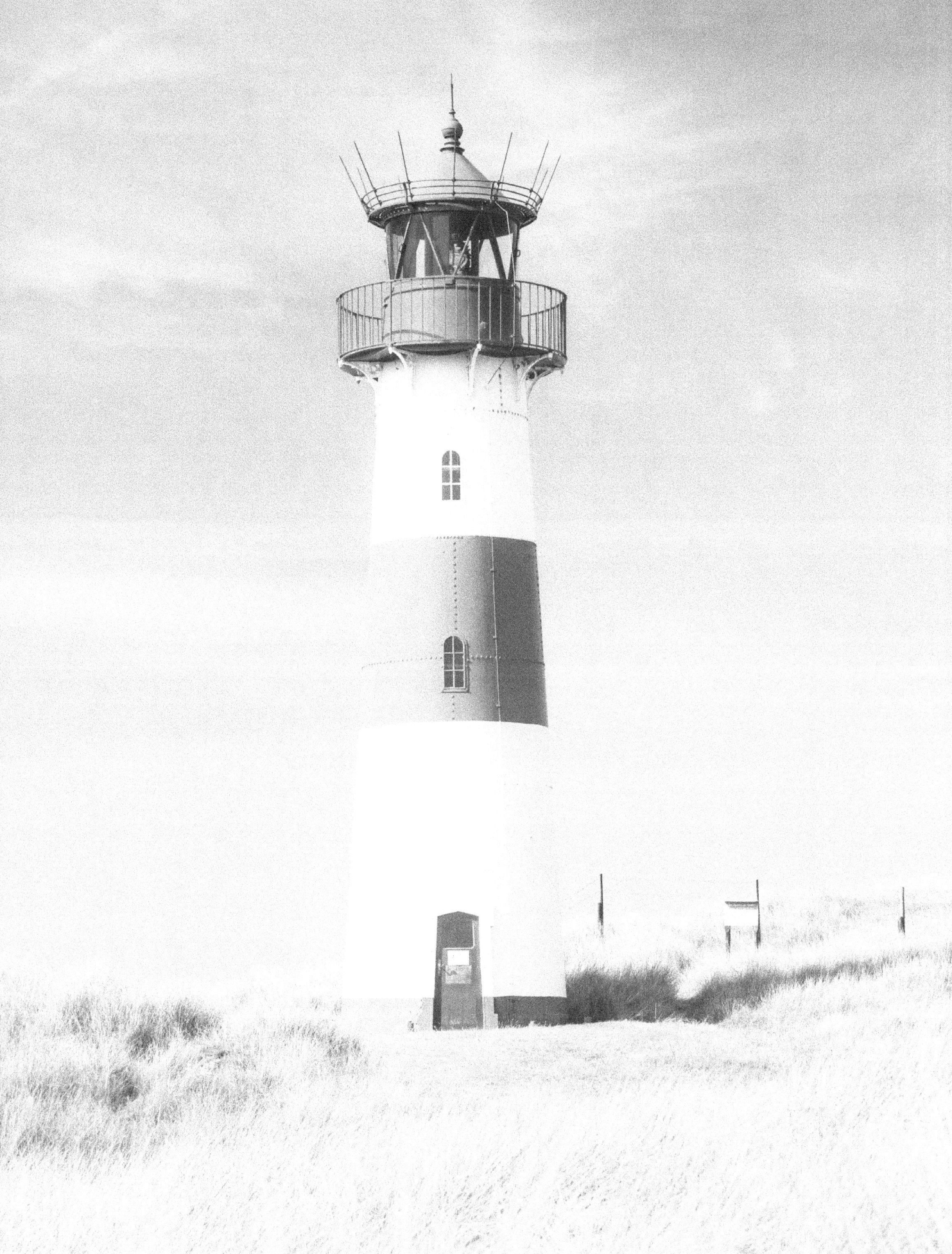

Materials Used:

Colored By:

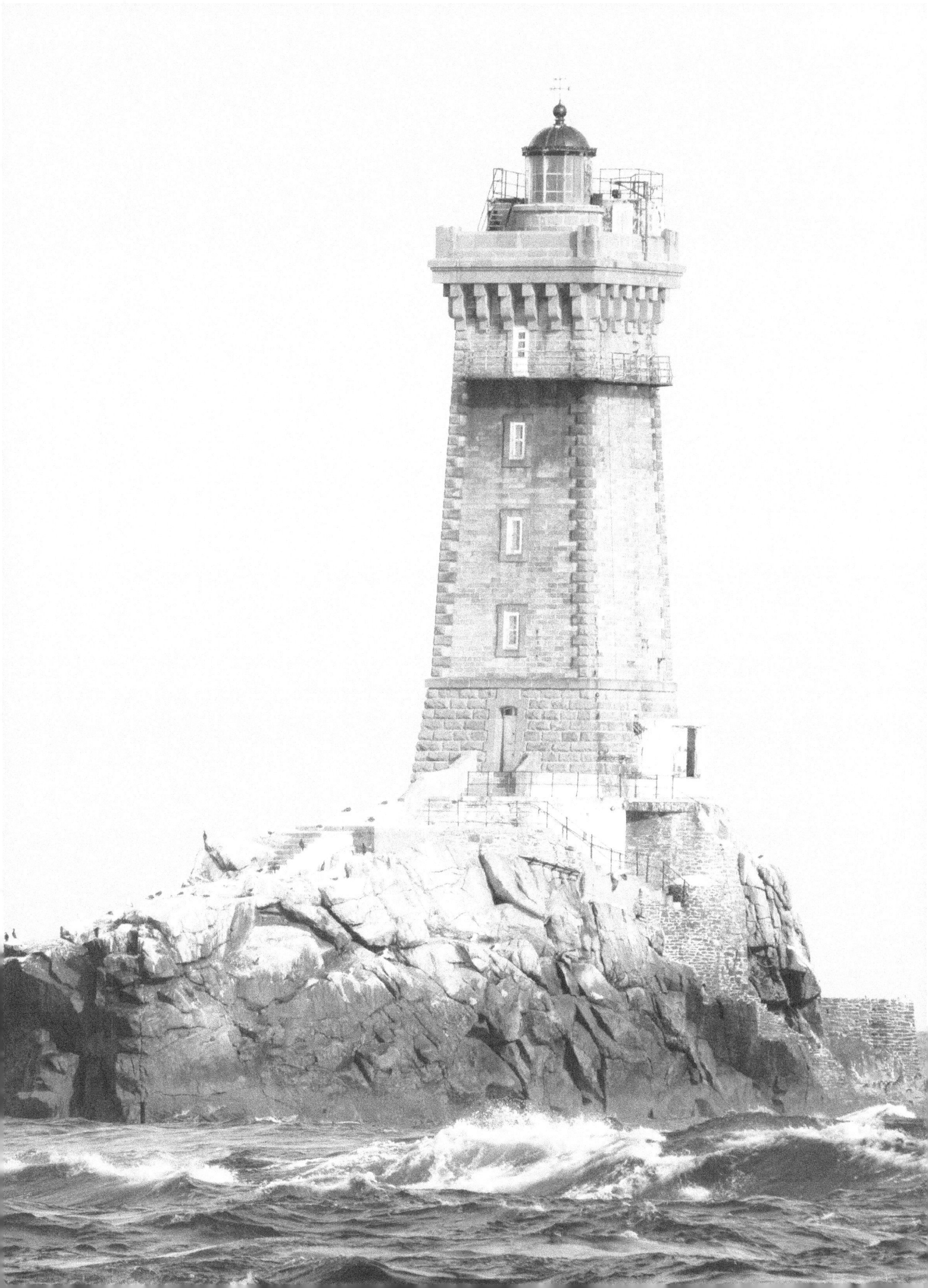

Materials Used:

Colored By:

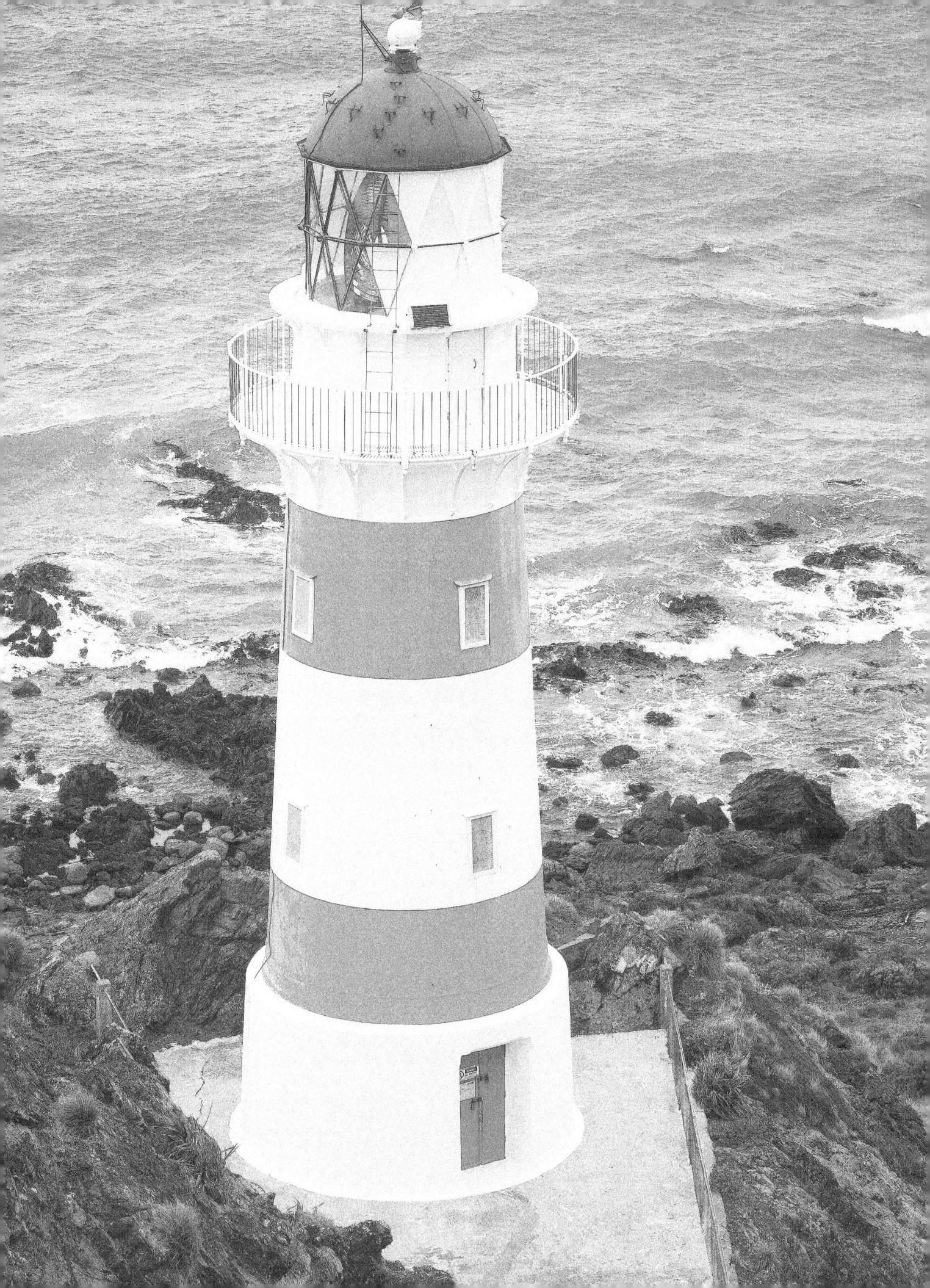

Materials Used:

Colored By:

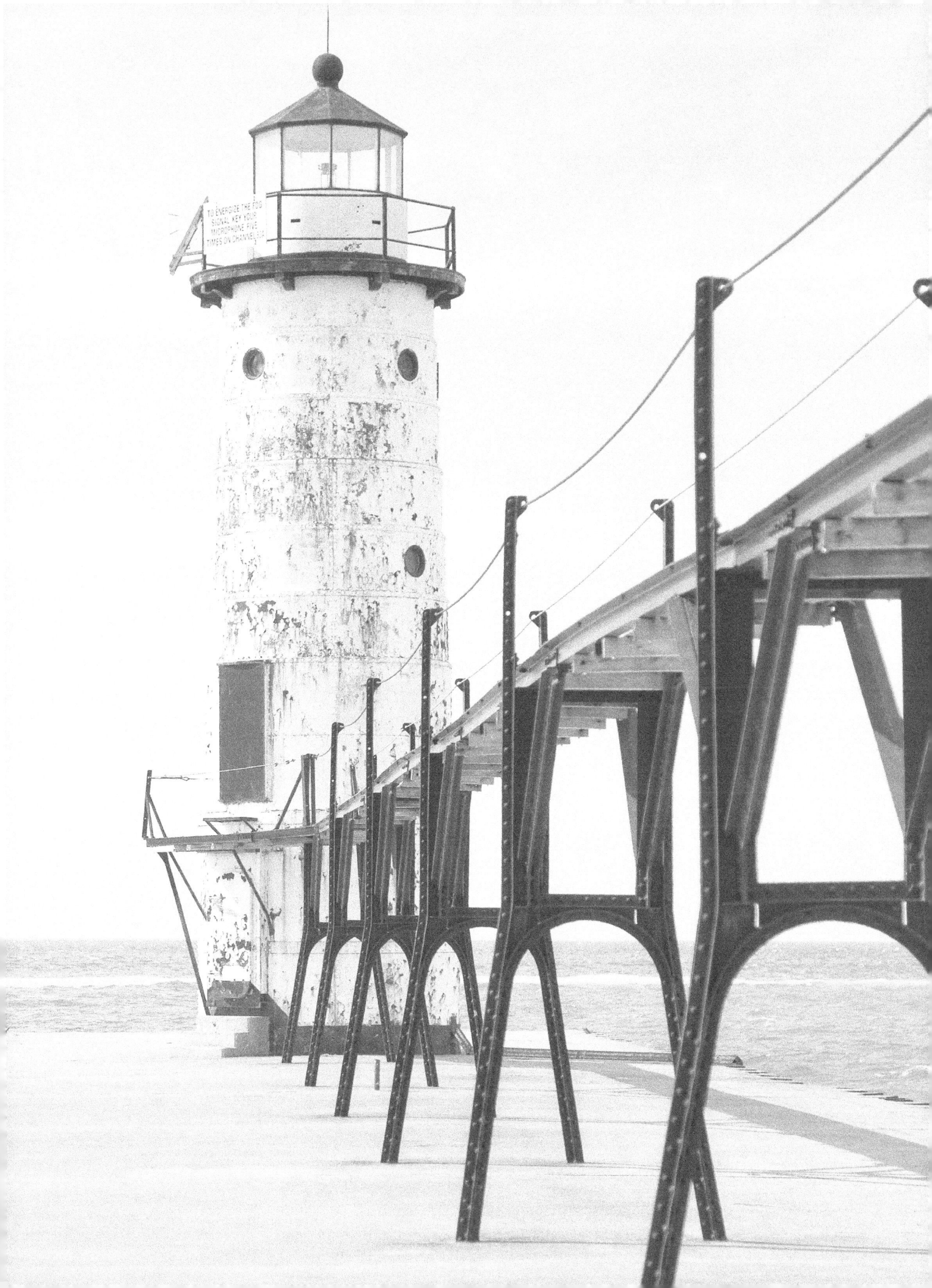

Materials Used:

Colored By:

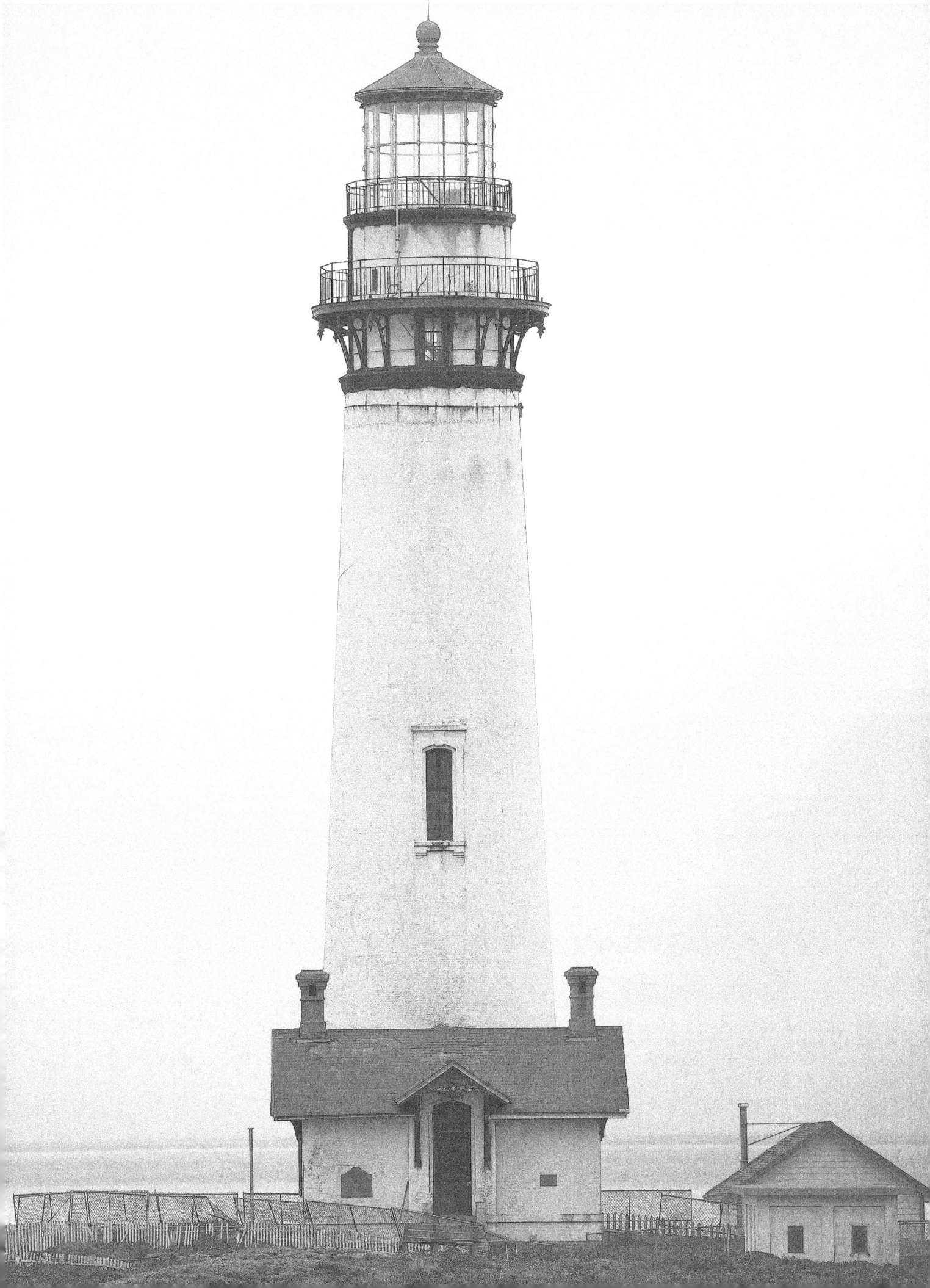

Materials Used:

Colored By:

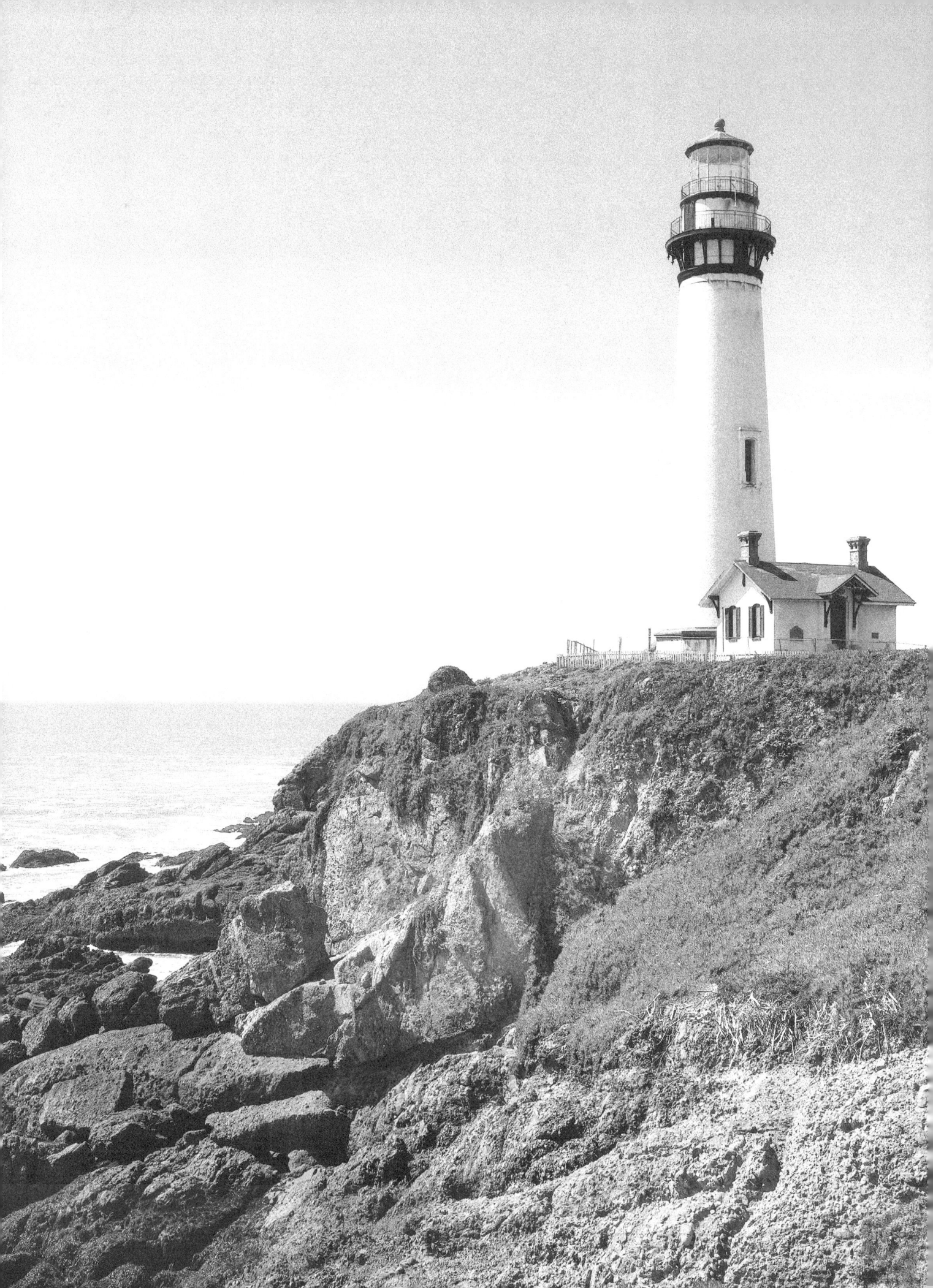

Materials Used:

Colored By:

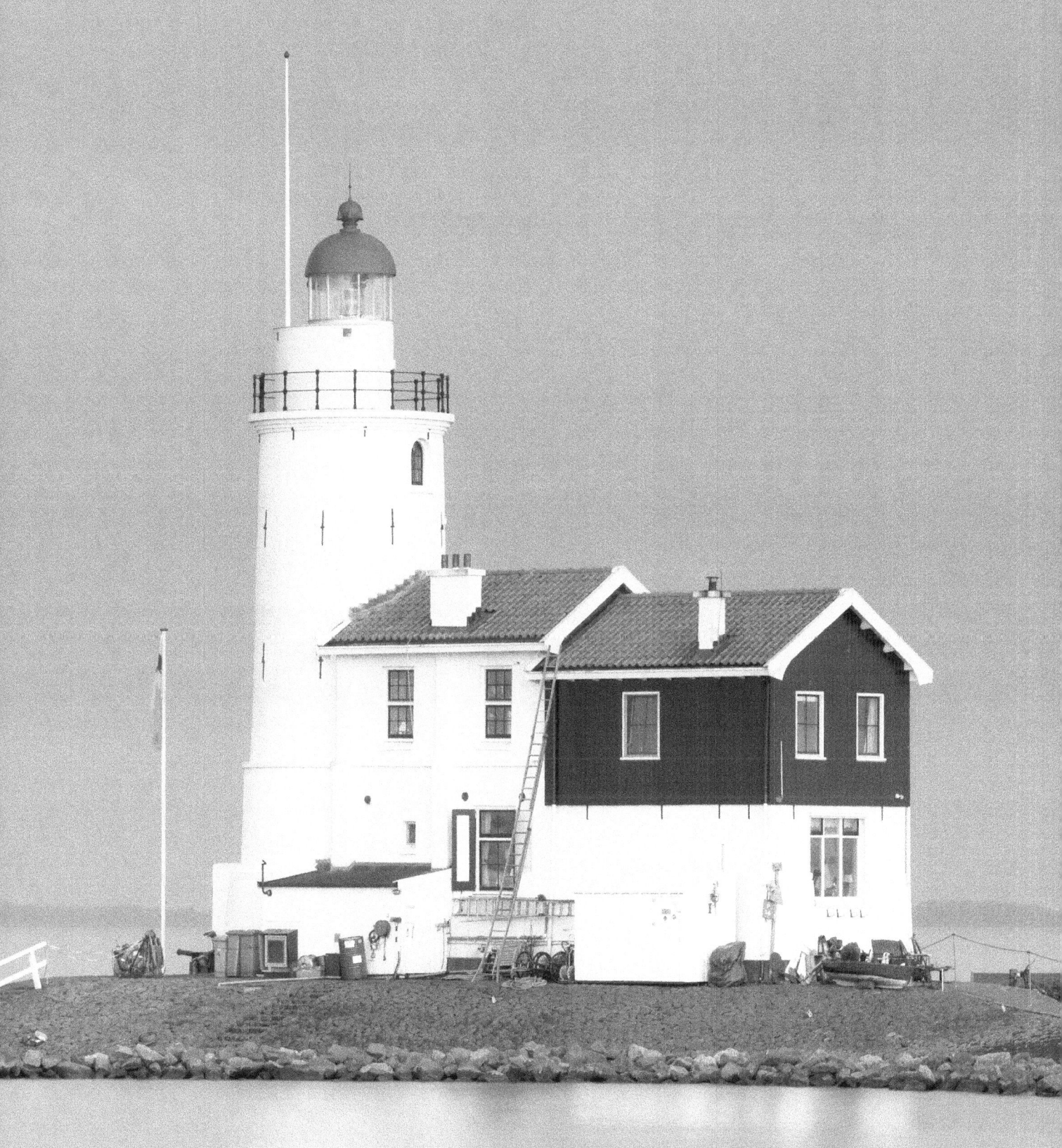

Materials Used:

Colored By:

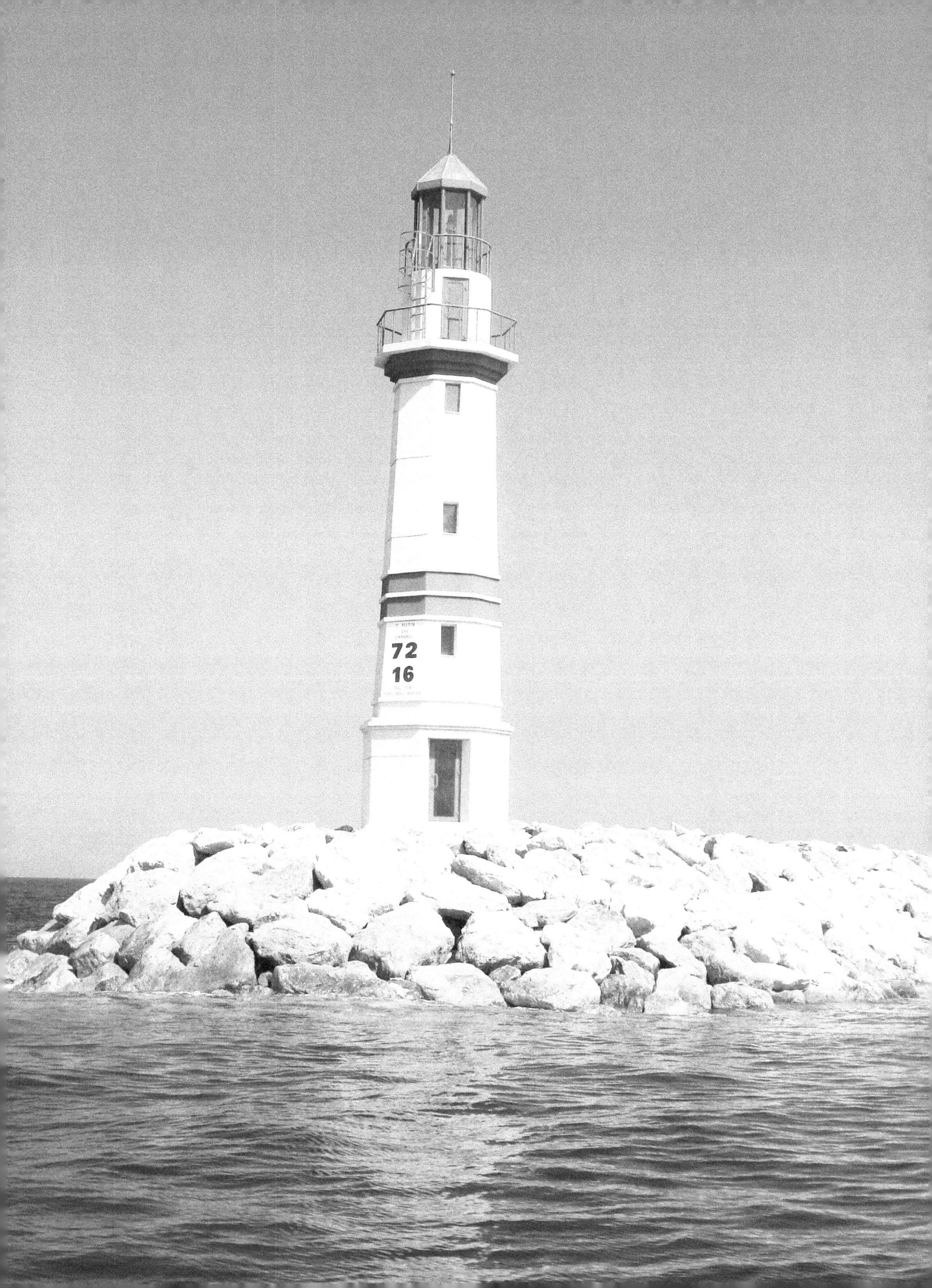

Materials Used:

Colored By:

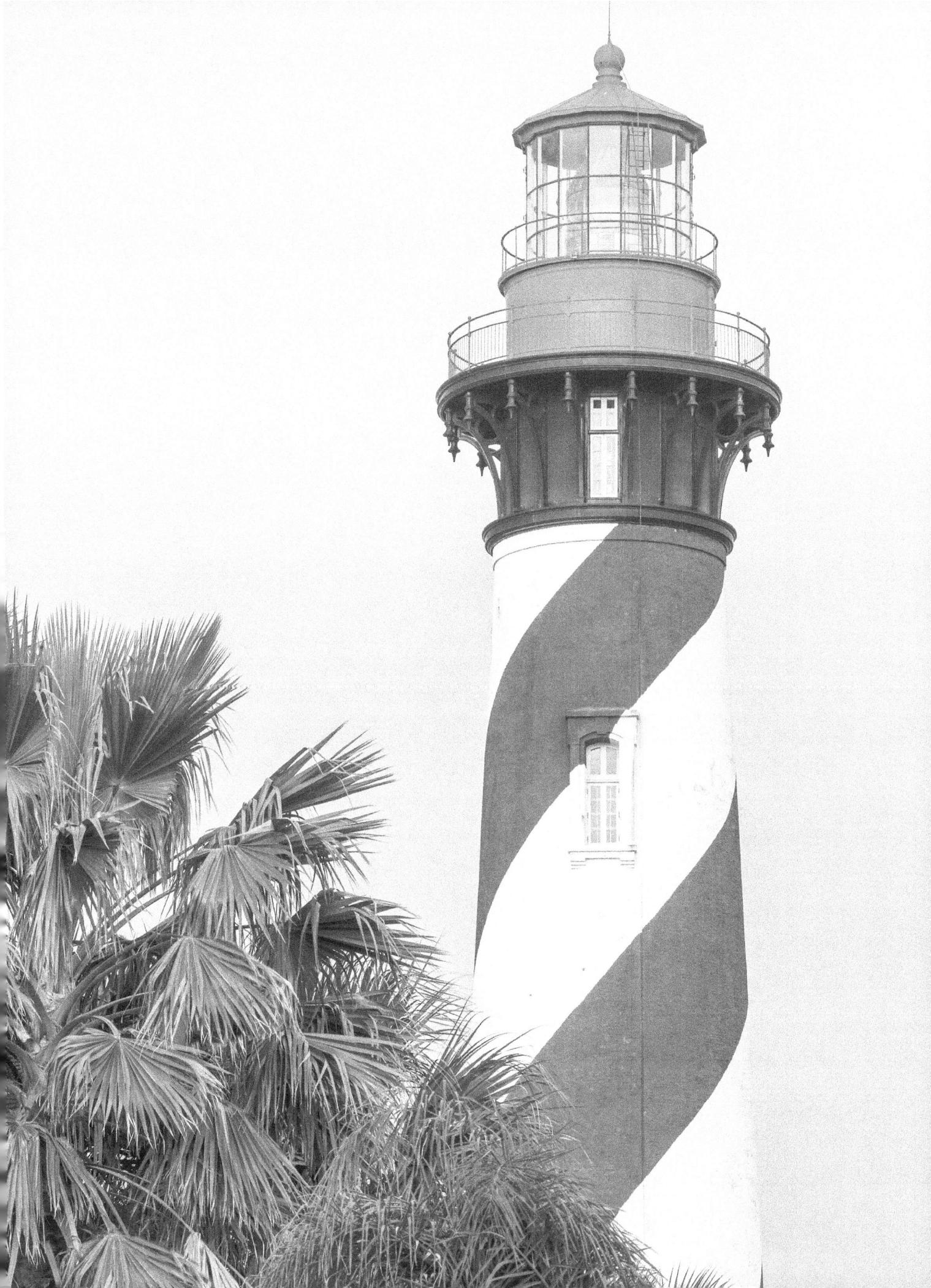

Materials Used:

Colored By:

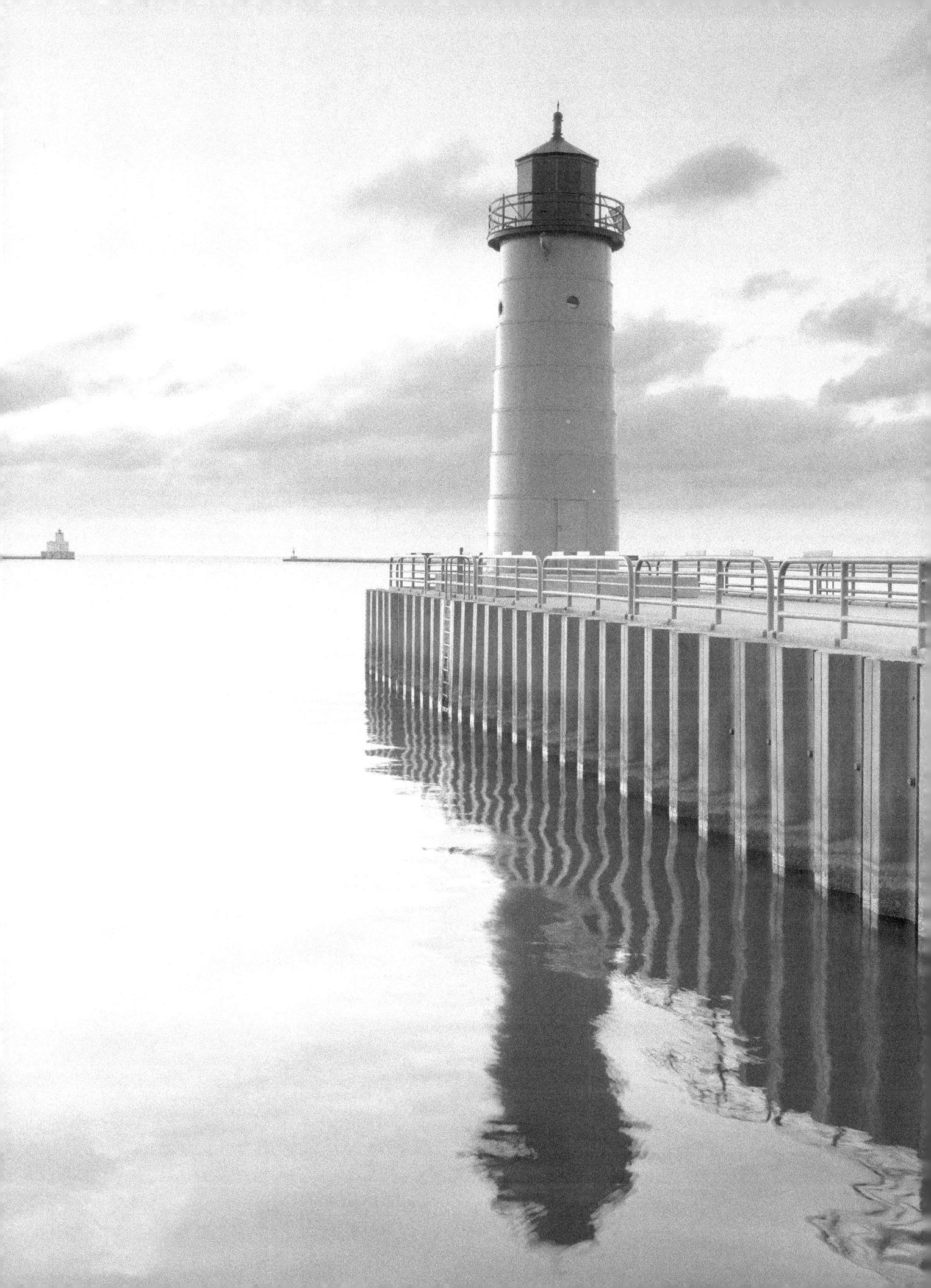

Materials Used:

Colored By:

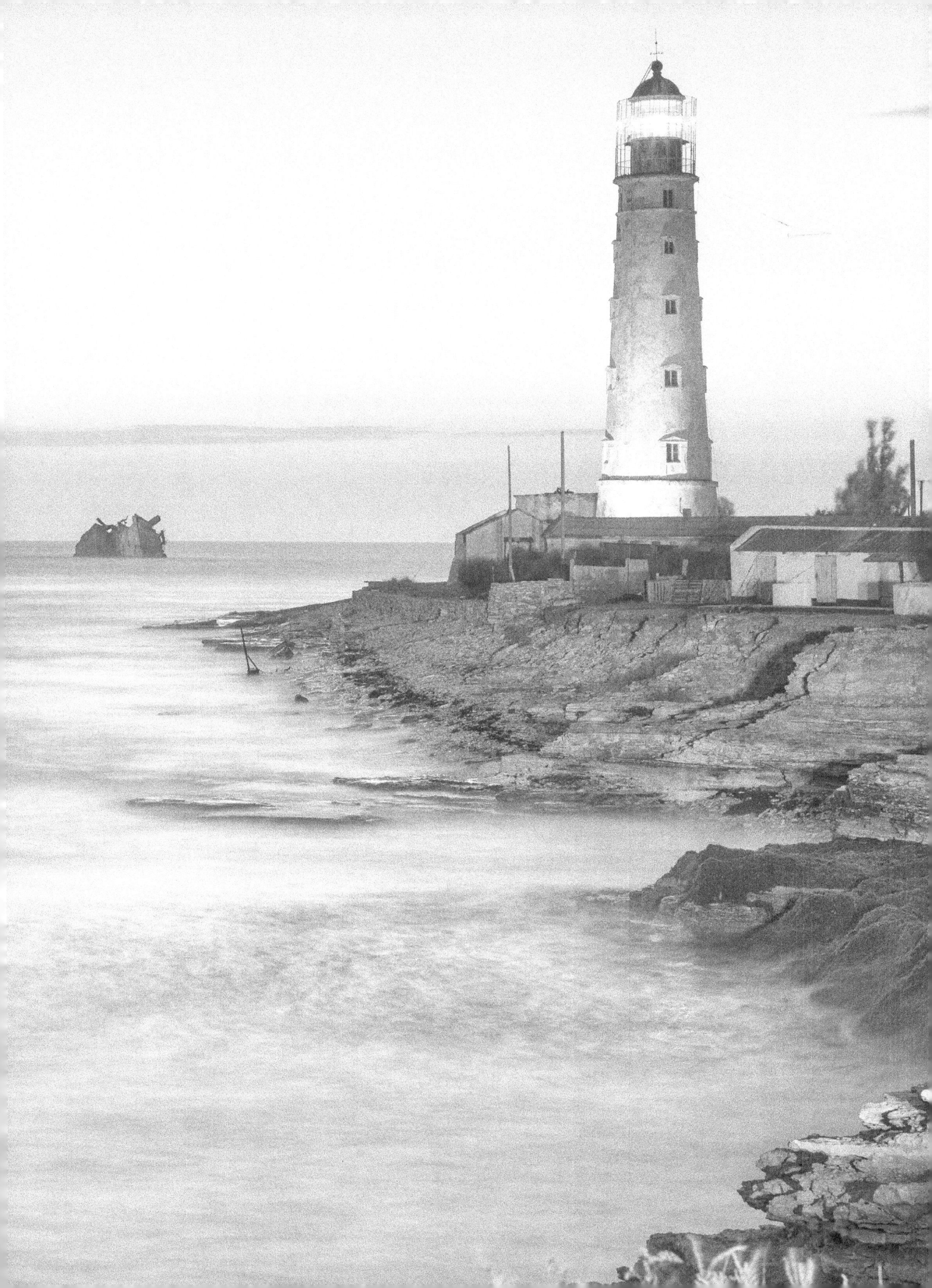

Materials Used:

Colored By:

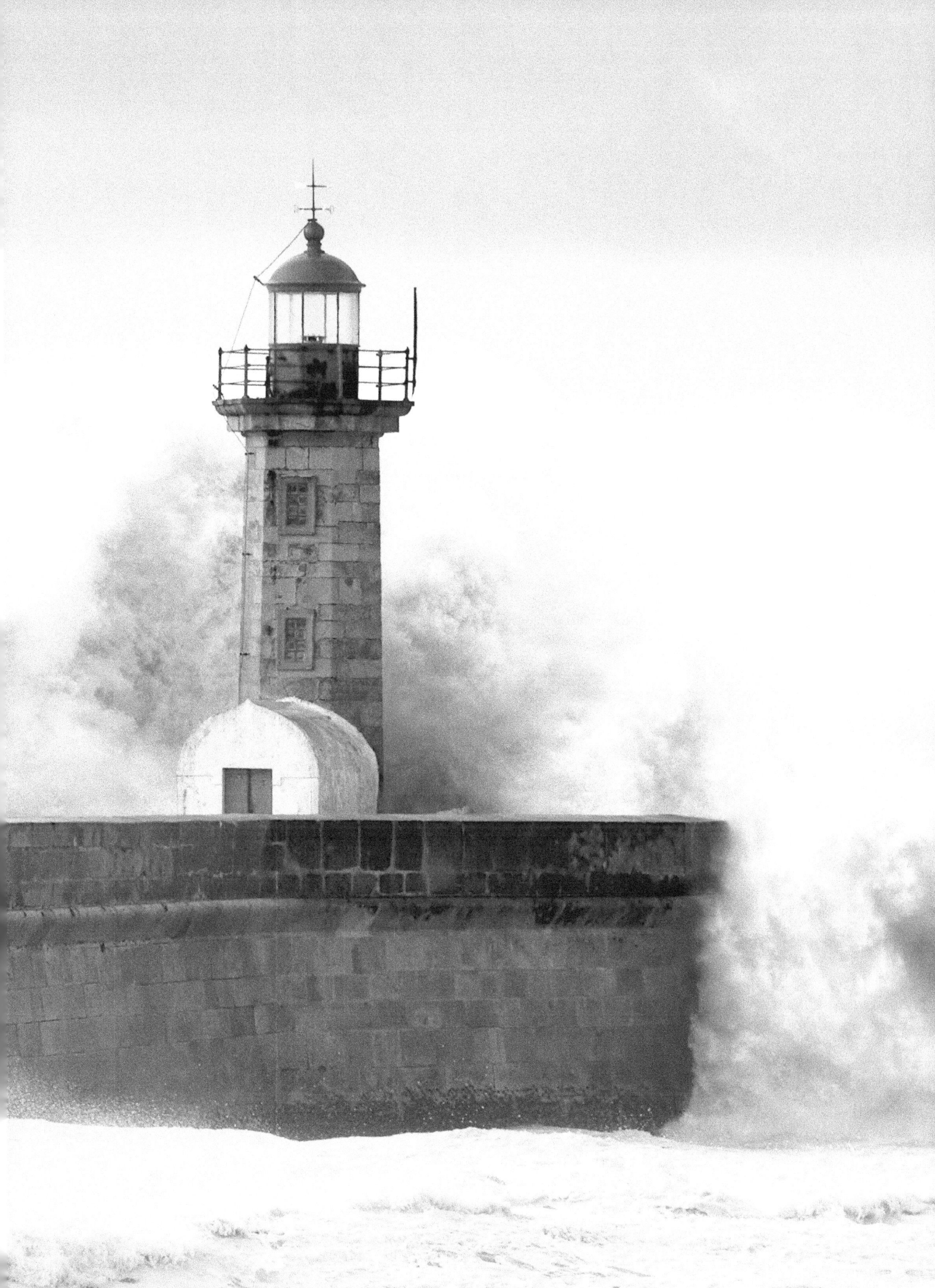

Materials Used:

Colored By:

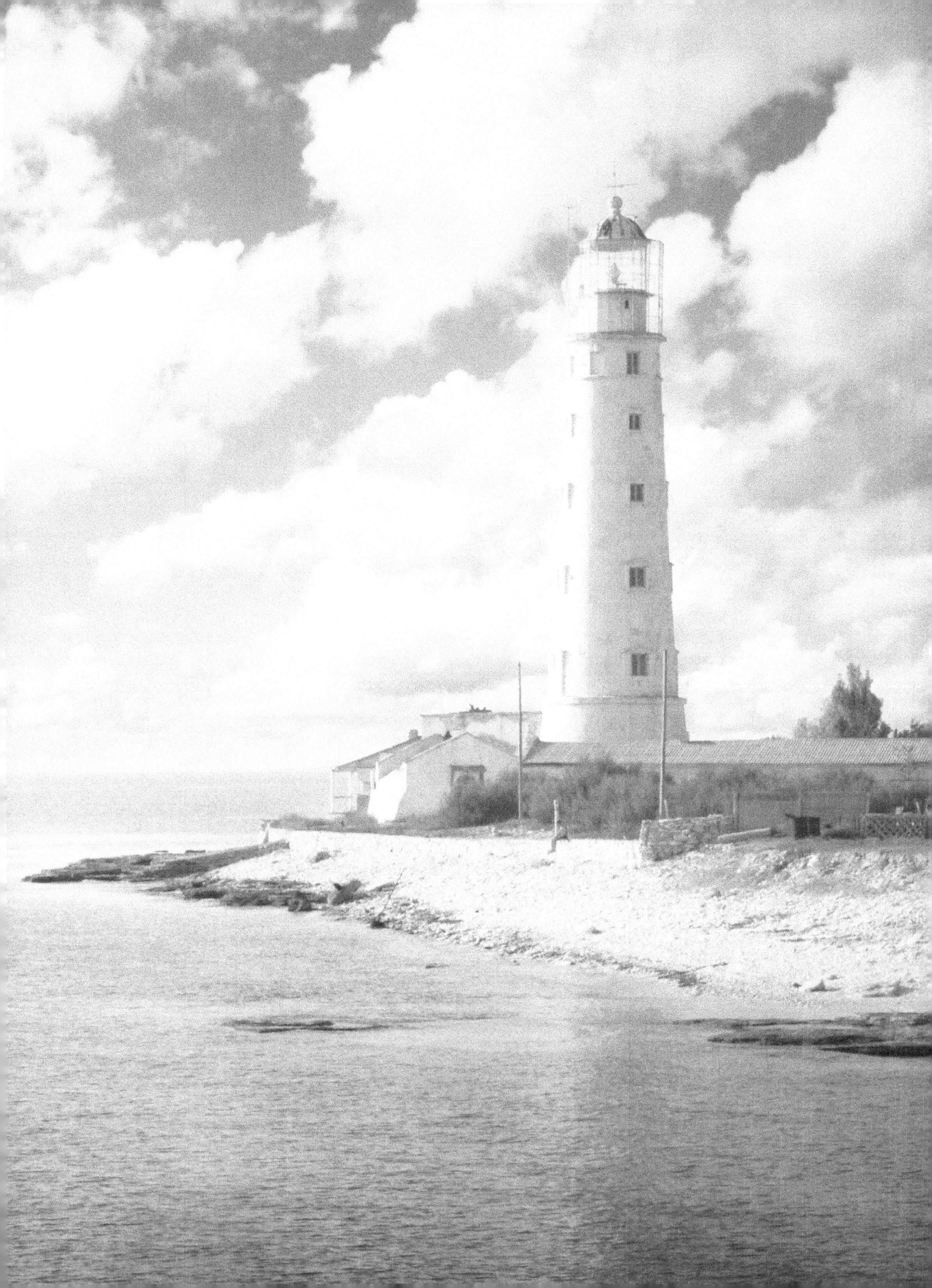

Materials Used:

Colored By:

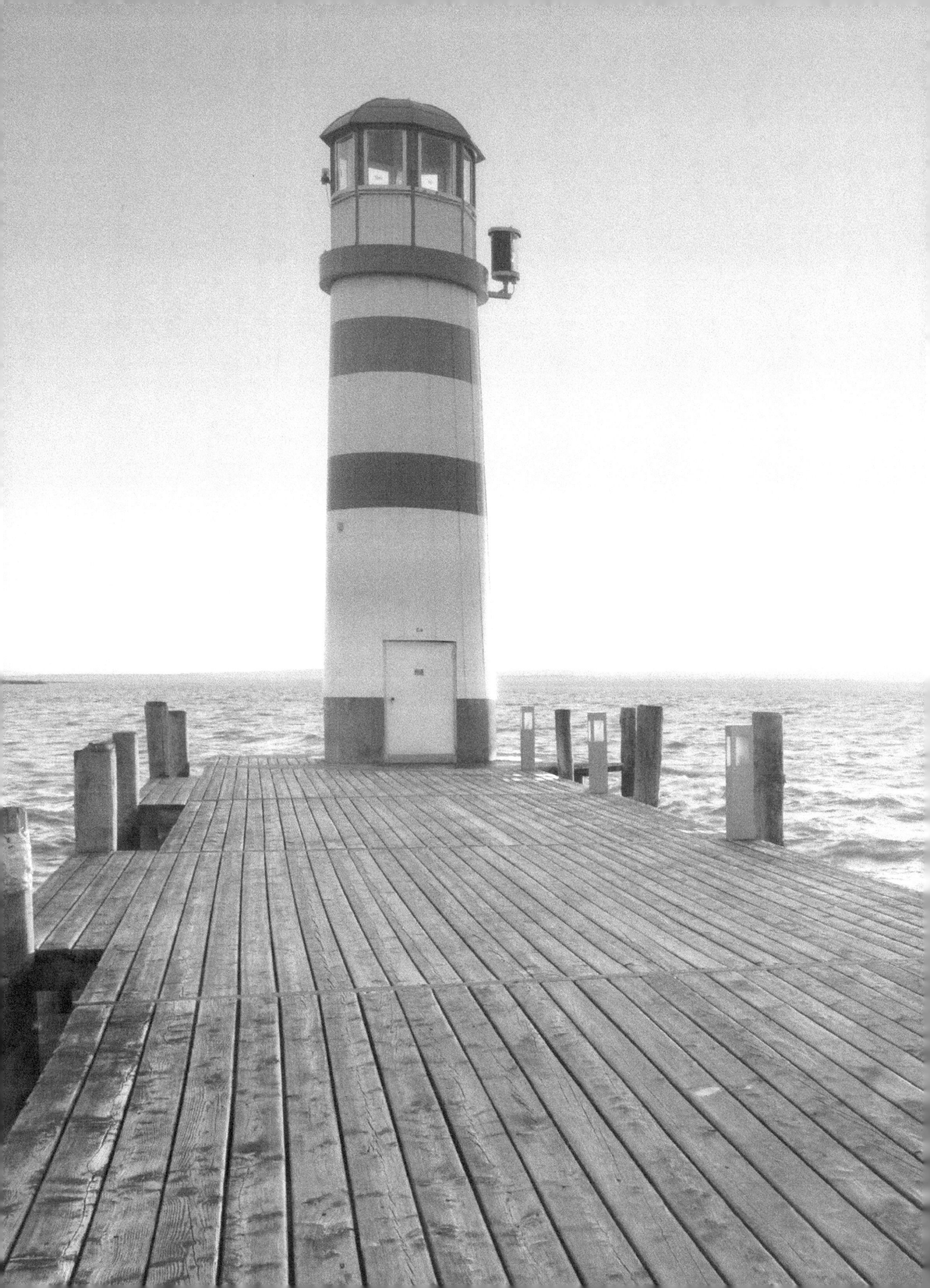

Materials Used:

Colored By:

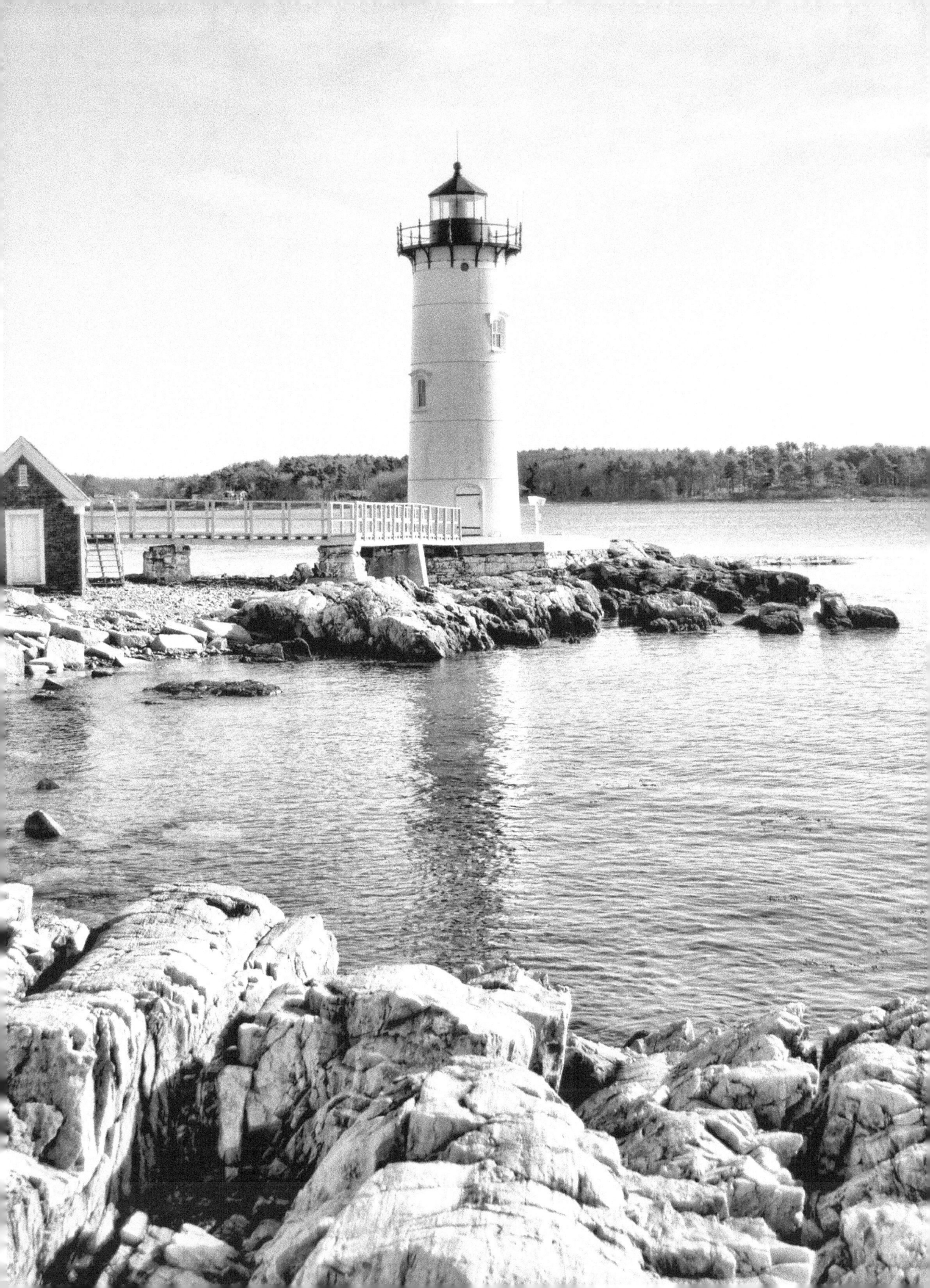

Materials Used:

Colored By:

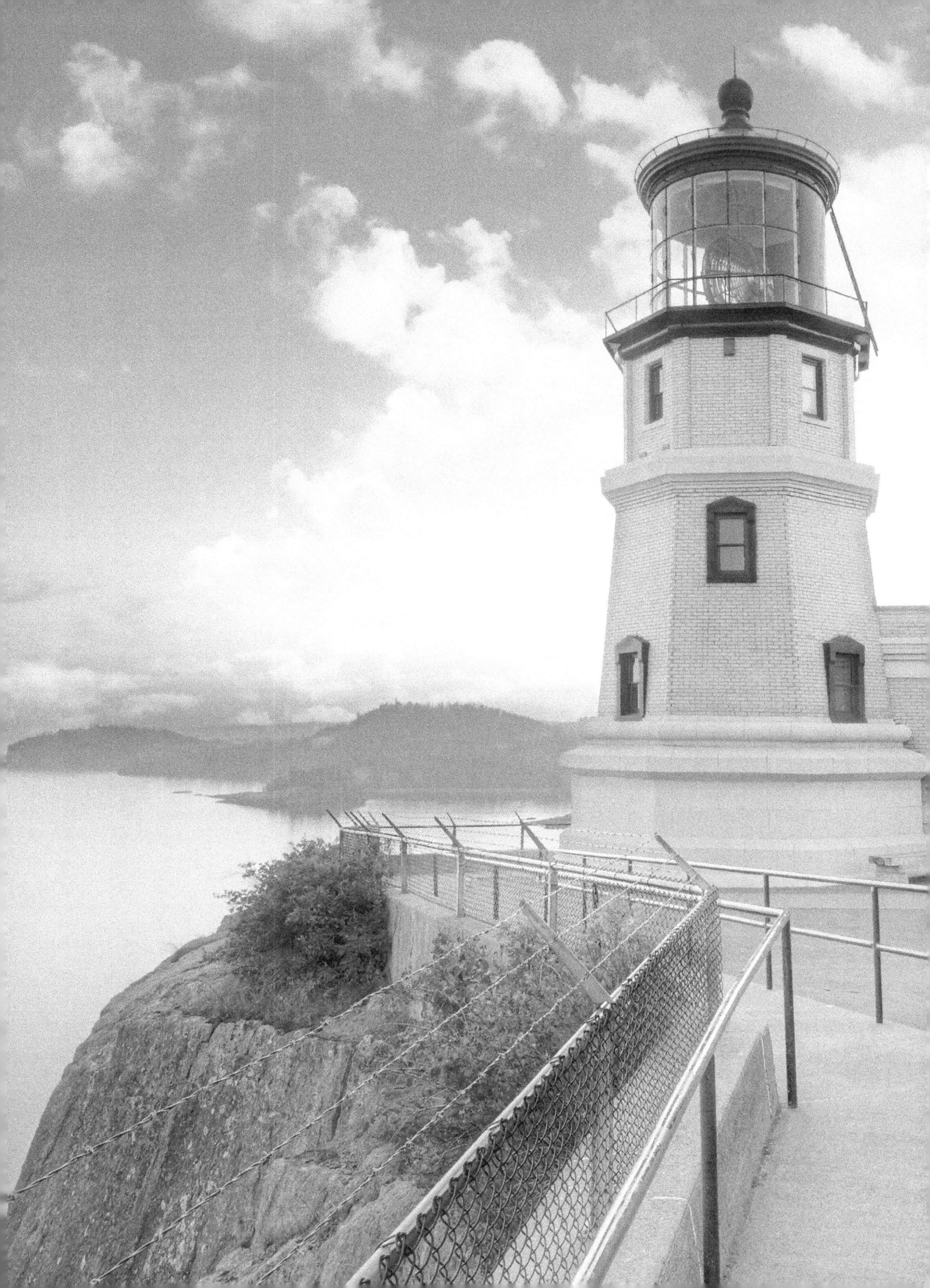

Materials Used:

Colored By:

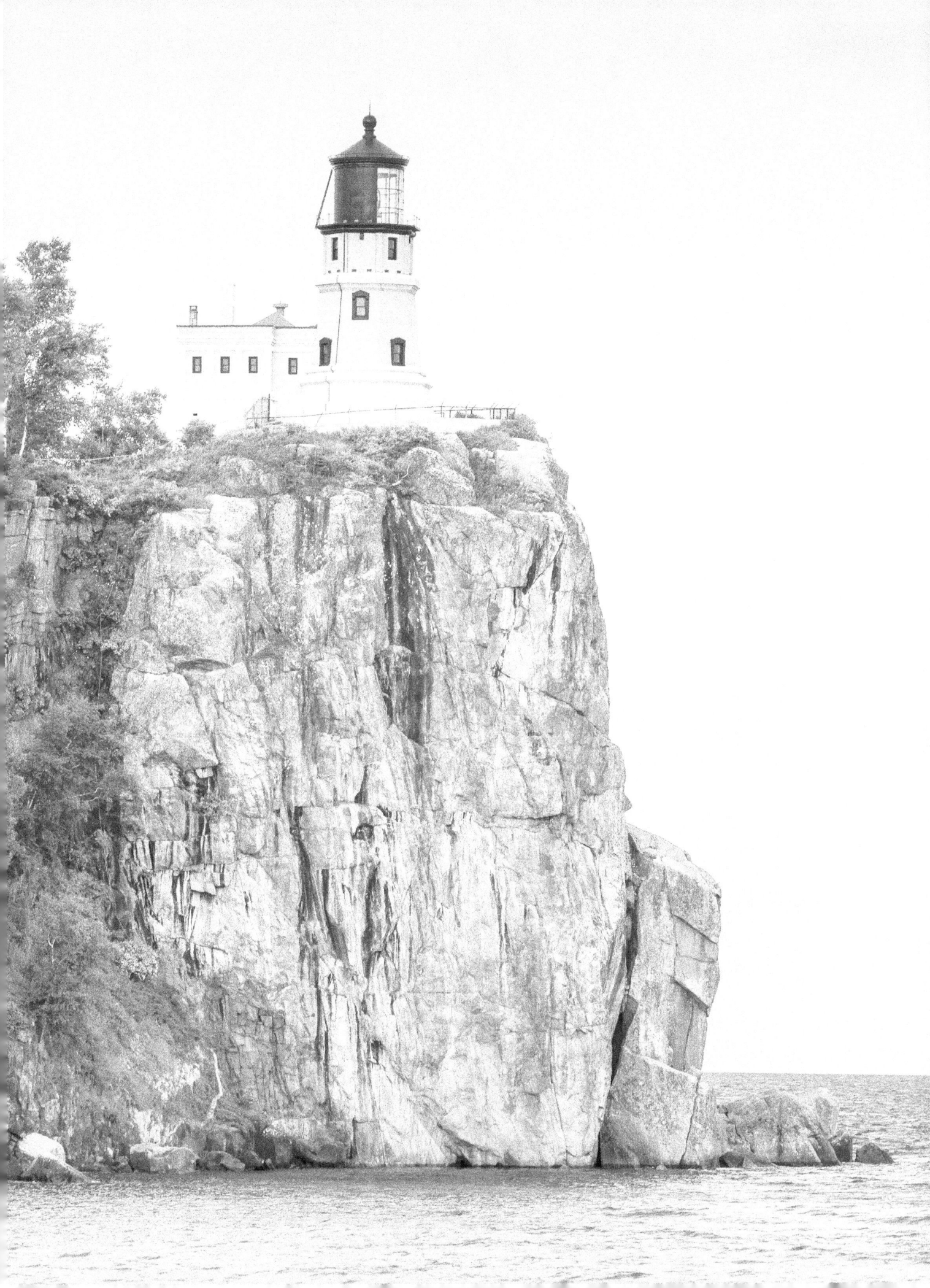

Materials Used:

Colored By:

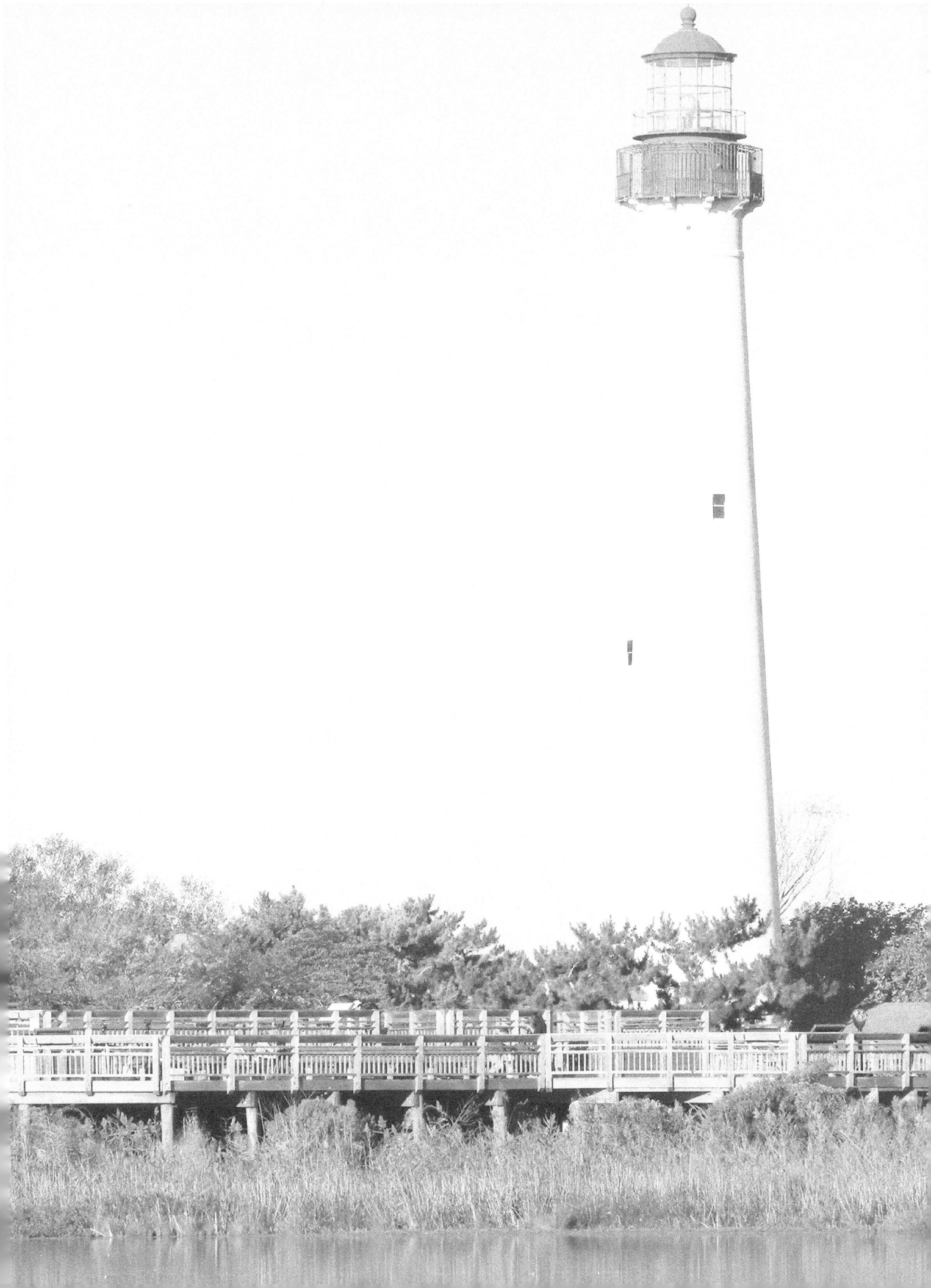

Materials Used:

Colored By:

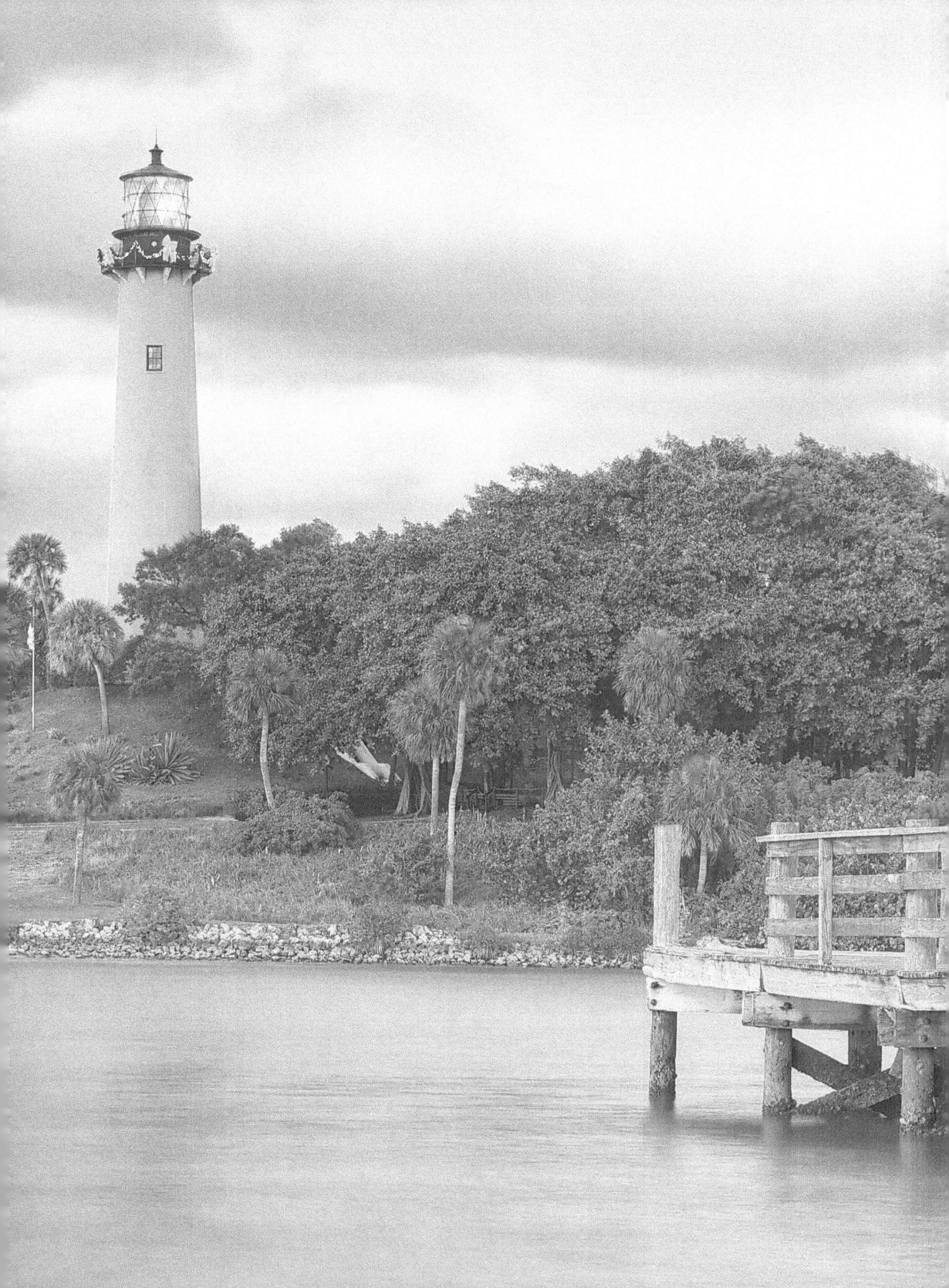

Materials Used:

Colored By:

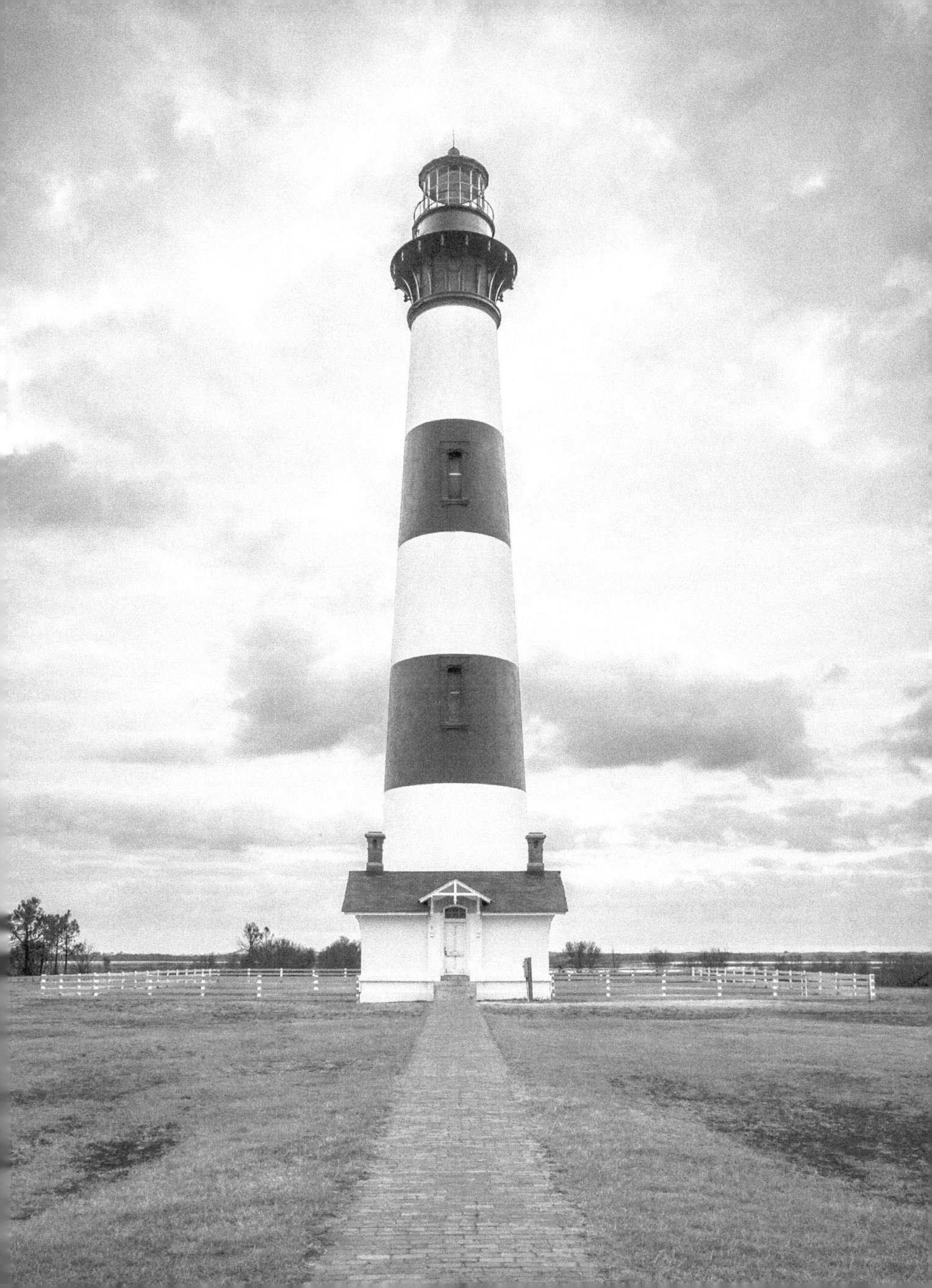

Materials Used:

Colored By:

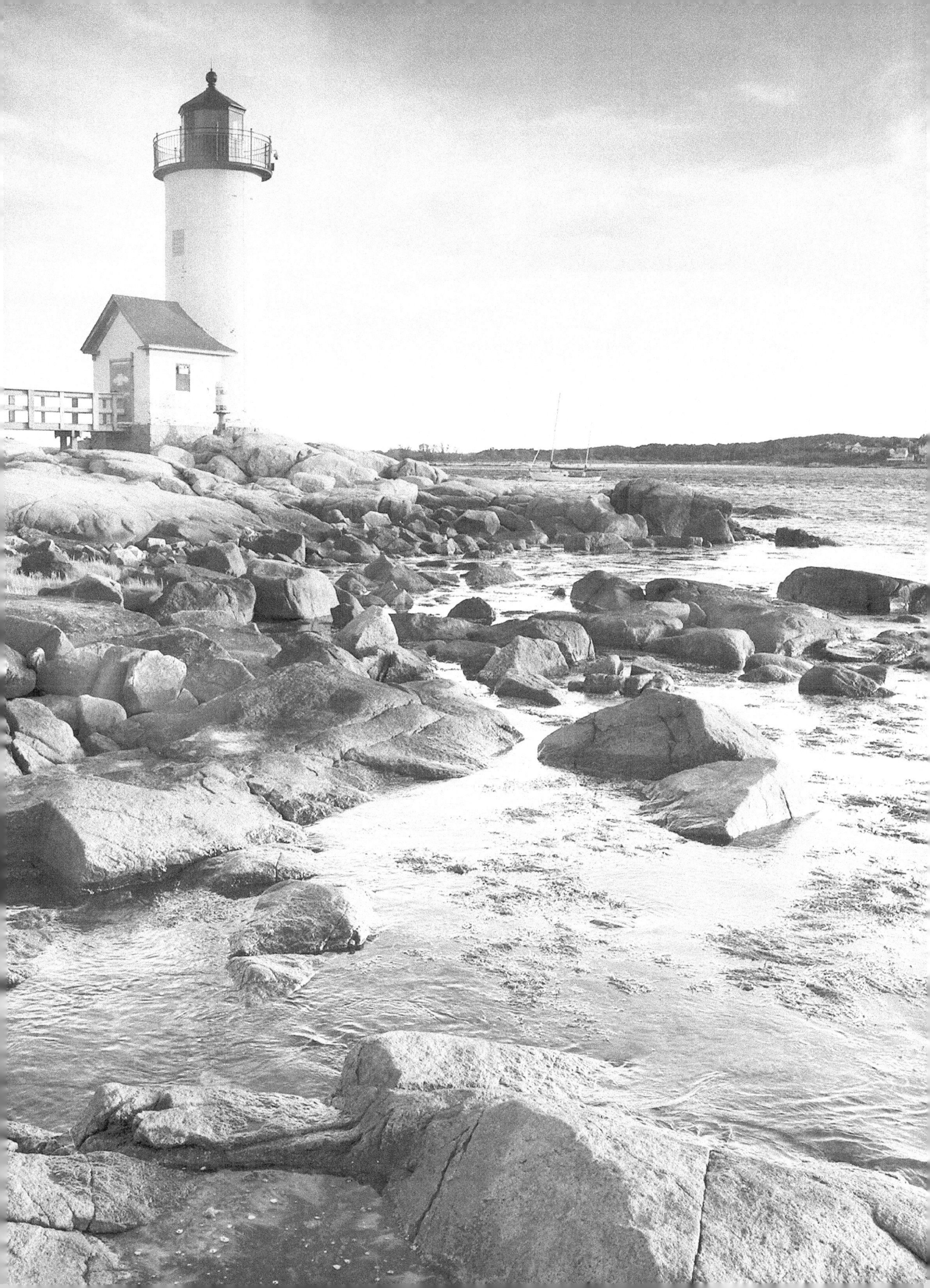

Materials Used:

Colored By:

www.ingramcontent.com/pod-product-compliance
Lightning Source LLC
Chambersburg PA
CBHW080556190526
45169CB00007B/2794